William Connelly & Paul Payne

Wyndham Payne
DESIGN

ACC ART BOOKS

Design Series format by Brian Webb

Design: Wyndham Payne © 2020 Paul Payne
Introduction text © William Connelly
World copyright reserved

ISBN: 9781788840651

The right of Paul Payne to be identified as the author of this work has been asserted by him in accordance with the Copyright, Designs and Patents Act 1988.

All rights reserved. No part of this publication may be reproduced, stored in a retrieval system, or transmitted in any form or by any means electronic, mechanical, photocopying, recording or otherwise, without the prior permission of the publisher.

British Library Cataloguing-in-Publication Data
A catalogue record for this book is available from the British Library

The author and publisher gratefully acknowledge the permission granted to reproduce the copyright material in this book. Every effort has been made to trace copyright holders and to obtain their permission for the use of copyright material. The publisher apologises for any errors or omissions in the text and would be grateful if notified of any corrections that should be incorporated in future reprints or editions of this book.

William Connelly's text first appeared in Studies in Illustration (Winter 2005/6).

Opposite: Wyndham Payne, on the right, flew in M. Salmet's pioneering Blériot monoplane from Woodley, near Reading, Berkshire, in October 1913. Flying from London to Paris in 1912, Salmet clocked a time of three hours sixteen minutes, at a record altitude of 9,000 feet; overpainted French and British flags can be seen on the side of the aeroplane.

Photographs on pages 6 and 7 copyright Reading Museum (Reading Borough Council). All rights reserved. Illustrations on pages 74 and 75: © Paul Payne/Victoria and Albert Museum, London. Photographs on pages 18, 86 and 87 taken by Eleanor Fuller.

Endpapers: cover detail from Parisian Nights: A Book of Essays by Arthur Symons, published by Cyril William Beaumont, London, 1926.
Covers: Christmas pattern papers, proof.

Printed in China
for ACC Art Books Ltd, Woodbridge, Suffolk, England
www.accartbooks.com

Design by Webb & Webb Design Limited, London

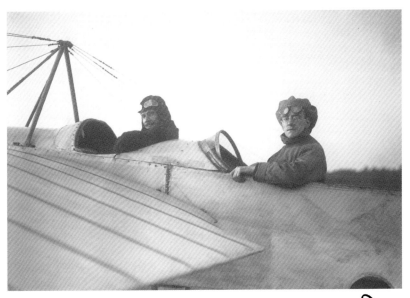

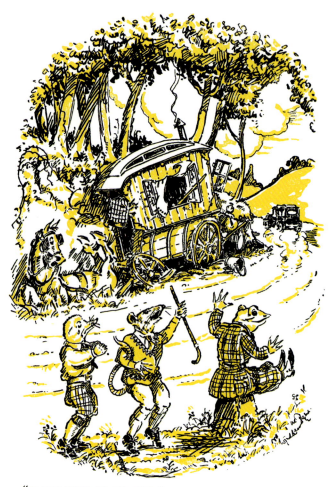

"O *STOP* BEING AN ASS, TOAD," CRIED THE MOLE DESPAIRINGLY

Payne produced all the illustrations for Methuen & Co.'s 1927 edition of Kenneth Grahame's *The Wind in the Willows*.

Design
Wyndham Payne

In 1924 a young man, lately a representative of the biscuit manufacturer Huntley & Palmers, made his way to the shop of the publisher, bookseller, ballet historian and critic, Cyril W. Beaumont, at 75 Charing Cross Road, London. Beaumont recalled the meeting:

'I received a visit from a young man in his late twenties or early thirties. He was tall and clean-shaven except for a small clipped moustache. The front of his hair had receded to give him a broad forehead, and he wore rimless pince-nez. His jerky manner was enthusiastic and eager, and he had a quaint trick of stressing his words which produced a slight hesitancy of speech. He was carrying a large attaché case and asked me if I could spare the time to look at some of his drawings.

'I told him that I should be pleased to see his work, whereupon he deposited his case on to an adjacent table, smiled pleasantly, and raised the lid with the air of a conjurer about to perform a spectacular sleight of hand.

'I had expected a score or more drawings at most, but there were hundreds, all shapes and sizes, and done on many varieties of paper. There were hands and busts and complete figures; animals, birds, and groups of people; trees, houses and cottages; suggestions for covers, labels, and notepaper headings. Many of them were washed with colour. There was a sense of freshness and good humour about them, which was quite exhilarating.

'He asked me if I had any publications in view which he might illustrate; and seemed a little downcast when I explained that my publications for the year were already issued or in hand. But I promised him that, when I had such a book, I should not fail to ask him to come and see me. He said at once: "Then may I leave my card?" A mutual good-morning and shake of the hand, and he was gone. I glanced at the piece of paste-board, the name on it was Wyndham Payne.'

* * *

Beaumont did not forget his promise to Payne and engaged him later in the year to decorate a small pamphlet on Burmese dances:

'Then I remembered I had once had an idea for a children's book, which I had begun but never finished and so set aside. Certainly it would lend itself admirably to such decorations as these…

'I told [Wyndham Payne] that I should be happy for him to decorate the story. It would be called The Mysterious Toyshop and it would be something new in relation to my publications, and well-suited to the approach of Christmas.'

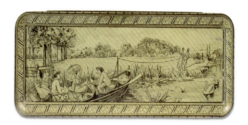

Albert Wyndham Payne was born on 2 February 1888, in Reading, Berkshire, to Fanny Elizabeth (1848-1930), daughter of James Gould, a wheelwright of Kingsland, Herefordshire, and William Henry Payne (1854-1912), a legal clerk. Wyndham was raised in a house of curiosities; his father collected furniture, pictures, local antiquities and found objects, all displayed in his private room – his cabinet. It was an environment that would shape Wyndham's honed turn of imagination and later interests. He had two brothers: Reginald, who fought in the Boer War and then settled with his wife and family in Australia; and Cecil, who trained initially as an architect but later became a dealer in antiques.

Wyndham was educated at the Kendrick School, Queen's Road, Reading. On leaving school he joined the biscuit manufacturing company Huntley & Palmers, at that time the largest biscuit maker in the country, employing 5,000 people. It was for many years the largest employer in Reading. (Today, significant collections of Huntley & Palmers biscuit tins are held at Reading Museum and Manderston House, Berwickshire.)

* * *

Design – Wyndham Payne

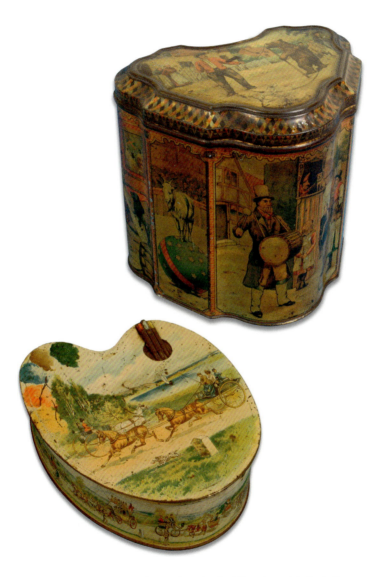

Huntley & Palmers' biscuit tins may have inspired Payne's work in illustration: the *Showman* tin dates from 1897, the *Palette* tin from 1903 and the *Boating* tin (opposite) from 1888 to 1890.

* * *

Wyndham had enlisted as a Trooper in the Royal Berkshire Imperial Yeomanry in 1913 but, undeterred by a near fatal aerial adventure, was commissioned 2nd Lt. Special Reserve, Royal Flying Corps (Military Wing) in 1916. His eyesight would not allow him to serve as a pilot, but as he had a talent for mechanical things, he was fortunate in being charged with supervising aeroplane maintenance. He was posted to 14 Wing BEF and, shortly after, appointed Wing Adjutant when 14 Wing moved to Italy with the Italian Expeditionary Force.

Wyndham married Dorothy Constance Craven (1891-1977), daughter of Arthur Craven of Cullingworth, on 26 July 1917, at St Martin-in-the-Fields Church, Trafalgar Square. After their marriage, the couple settled in a rented cottage at Harmston while Wyndham was serving at nearby RFC Waddington, five miles south of the city of Lincoln. It was here that they published privately a book of Dorothy's, *Poems from the Fireside*, with a cover decoration by Wyndham of a cat before a blazing fire; a scene of domestic comfort that would become a leitmotif of his later work. The design is executed in bold black line over grey paper, in a style which, with later refinement, he made his own.

On demobilisation as Acting Captain, Royal Air Force, Wyndham resumed his position with Huntley & Palmers. He and Dorothy settled at 27 Guild Hill Road, Southbourne-on-Sea, Hampshire, where their son Paul was born in 1920. He was their only child.

Wyndham had drawn constantly and made models since childhood but it was a step of some daring with a wife and child to decide, without training, to make art his career. It was Dorothy's father who encouraged Wyndham to become a freelance artist. He left Huntley & Palmers, and started putting together a portfolio of illustrative and decorative work. The hunt for work began. No doubt his experience and confidence as a representative for Huntley & Palmers was a great asset in making himself known to publishers and agents.

It makes for a good story but Cyril Beaumont was perhaps disingenuous to imply that Wyndham Payne's reputation was unknown to him in 1924; such a man, *au fait* with the world of

✱ ✱ ✱

Design – Wyndham Payne

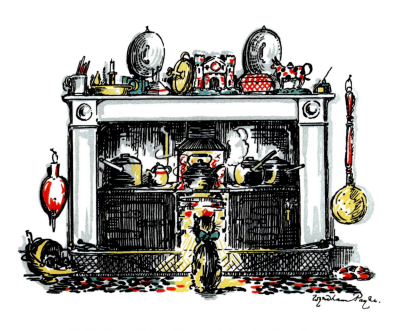

The fireside cat, first used to illustrate Dorothy's *Poems from the Fireside*, became a recurrent motif in Payne's illustrations. This version was produced for a book of poems by Basildon, published by The Medici Society. Dorothy – 'Dotty' – diligently collected her husband's work, filling scrapbooks with his drawings, watercolours and prints.

✳ ✳ ✳

books, would surely have known of his work. Wyndham had contributed many small drawings in 1923 to *The Bodleian*, published monthly by John Lane, and in June, Walter Bradley (the editor of *Type. A Journal devoted to Printing and Book-Production* published by the Morland Press) wrote in his introduction to the issue: 'The whole of the designs in this number are from the pen of Mr. A. Wyndham Payne, who is young, full of ideas and works very rapidly. He is much appreciated in the realm of business art.'

Other favourable comments soon followed from the likes of G. Gress, editor of *The American Printer*, and from Haldane Macfall, who wrote a postcard to Bradley in July 1923 which read: '*Type* charming. Wyndham Payne quite a discovery.'

In August 1923 *Commercial Art* noted that his illustrations were 'best described as jolly and full of life'. *The Woodcut* also took note of the drawings in *Type*: '[Wyndham Payne] has an extremely agreeable knack of getting strong effects in a restful way.' In the provincial press, a review appeared in the *Wiltshire Gazette* on 5 July 1923 and in the *Aberdeen Press and Journal* on 20 July, describing Wyndham as 'a young artist of original and attractive ideas'.

Arthur Lawrence, writing in *Drawing and Design* in April 1924, described Wyndham as 'a young artist whose work owes something to the memory of the late Claud Lovat Fraser'. However, any similarity between the two artists was most likely to have come from their shared inspiration: the anonymous illustrators of nineteenth-century popular literature and others such as Cruikshank, 'Phiz' and certainly Joseph Crawhall (1821-1896), a copy of whose *Old Aunt Elspa's ABC* was in Wyndham's library. It could, perhaps, be argued that the influence of Fraser can be detected in Wyndham's later work, particularly in the design and style of his decorative floral borders. Lawrence continued:

'At his best, Mr Payne has a freedom of line which proves most refreshing… He will do well to boldly retain his freedom of hand and let us have the wind and the rain and the lights and shadows of sunshine, rather than tame his great ability to the restrictions of just pretty work… He has done well in many directions, and one can but hope that in the place of any arrested development he will retain his freedom and find an ever-increasing power to his elbow.'

* * *

Design – Wyndham Payne

...Wyndham had been noticed.

* * *

Cyril Beaumont wrote in *The First Score* (1927): 'It seemed to me a pity that modern writers should not be afforded an opportunity of having their works published in a choice form during their lifetime.' This then was the reason for the foundation of the Beaumont Press. All aspects of the publications were given careful attention: typography, illustrations and binding were all to be in sympathy with the text, simple and elegant – *simplex munditiis*, the motto of the Press. This ambition also applied to those trade editions published as C.W. Beaumont.

It is unclear why Cyril Beaumont, who had commissioned illustrators of reputation, was so attracted to the work of this self-taught artist. However, being congenial men with mutual enthusiasms – toys, model theatres – there was an immediate rapport between the two. Beaumont's letters to Wyndham were always cordial and he soon began to address him as 'My Dear Wyndham'. The letters, written in a very small hand, are often illustrated, some with a practical purpose but others as witty *mots justes* to an intimate.

Did Beaumont, the publisher, interfere and impose his ideas on Wyndham? Letters between other publishers and artists would suggest that he was no more demanding than was customary, but Beaumont, a very dynamo, was also the author and in this respect he was perhaps more intrusive. But, whatever a patron's involvement, a commission need not result in a lesser work of art. There were frequent meetings of the two at 75 Charing Cross Road but only Beaumont's letters survive of the early commissions. His suggestions were not strongly put, with phrases such as 'I suggest' or 'Would it be possible as soon as you are well enough' being the norm. He sent photographs and other material, and proposed ways in which problems might be resolved.

The only surviving diary entries in which Wyndham documents the making of a book for Beaumont are drawn from *Sea Magic*, his final commission for the publisher. On 12 June 1927, he wrote:

* * *

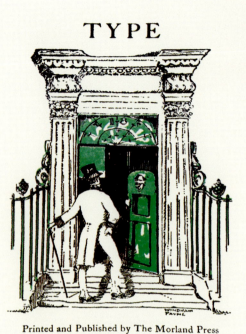

Payne contributed all the illustrations for the June 1923 edition of *Type*, a monthly journal from The Morland Press, 'devoted to printing and book-production'. The Morland Press was a publisher and printer of books and magazines on the arts; *The Apple* magazine first issued in 1920 and 'bought and enjoyed by high and low', included illustrations by McKnight Kauffer, Gaudier-Brzeska and Wyndham Lewis, and headings and tail-pieces by Claud Lovat Fraser.

'*Up to London by 9.10 train... Then to Beaumont's where I discussed with much detail particulars for the illustration of his story [Sea Magic] — we visited the Armed Services Museum for detail of ships & uniforms — then back to his shop where he proceeded to make a card board model of a ship such as the boy... in the story [made]. Studied books... then back to Waterloo to catch the 9.18 train feeling pretty tired but the day has been well spent & feel I can go ahead with work on the book.*'

However, another letter from Beaumont followed on 13 June 1928, accompanied by a copy of Treasure Island, from which Wyndham was to take note of 'that tropical atmosphere that I was trying to explain to you last night. The green is just right.' Wyndham would write in his diary on 9 July that Beaumont was 'such a stickler for details', and on 8 August that he was 'Victorianly [sic] pedantic'.

Whatever the trials of the commission for Sea Magic were, the book was well received. The Times Literary Supplement noted: 'Mr Wyndham Payne's little coloured illustrations invest seamen and buccaneers with Skeltic dash... this is eminently the sort of gift book to buy for the family and keep for oneself.' Despite such reviews, sales of the book were poor.

To return to their first collaboration for Beaumont's strange tale, The Mysterious Toyshop, Wyndham's small naturalistic drawings are charming and telling in their economy, bringing a faux naïve eye to the magic other-world of the toyshop. It is there in the drawing of the three full-page illustrations, and the way they are given the acid tang brightness of boiled sweets.

The Times Literary Supplement (20 November 1924) was impressed, noting: 'Mr Wyndham Payne's illustrations are a delight; instead of feeling that they have been casually added on, we feel that they are emerging from the story itself and actually creating it. Large or small, they are an enticing blend of pattern and vitality.'

The design of the book is stylish yet friendly. With a scarlet spine and title paste-down label over the patterned paper boards of Wyndham's design, it is invitingly jolly, an appearance surely inspired by the publisher and illustrator's idea of the book as an exciting present. It must have sung out from the booksellers' shelves. Beaumont busied himself promoting the book, as reported in a

* * *

letter he wrote to Wyndham on 7 November 1924:

'I went yesterday afternoon to the manager of the Kensington branch of Messrs Smith's. He is very pleased with the book and was delighted to have the illuminated sign… [Wyndham had made a model of the shop which lit up] He has promised to put the sign in the small central case [at the shop's entrance] with a display of the book. He has it on show inside, a kind of column of them crowned with a "felix" — it quite surprised me when I first saw it. He is going to do all he can for the book. I asked him if we could help in any way to increase sales and he asked me if I could let him have a poster for his room of children's books…'

Beaumont was an affectionate man, generous in his praise and indulgent with Wyndham. Another of their collaborations was entitled Town & Country, described by Beaumont as 'a kind of picture book for grown-ups'. Beaumont asked Wyndham to provide the designs, 'which were to be printed in black on Japanese vellum from cuts in various materials, principally wood and linoleum.'

The book was a large quarto, each print coloured by hand and mounted on the text paper. The edition was limited to 250 copies on antique wove paper and sixty copies printed on handmade paper and signed by the artist and publisher. The binding was Javanese batik paper sides and buckram spine, or parchment in the case of the edition de luxe. Wyndham enjoyed the commission, and in a letter he wrote: 'This evening I have begun the battle of the Nile and the chips are flying in all directions.'

Town & Country was a luxurious showcase for Wyndham's work — an album of coloured figurative and decorative woodcuts. The book was well received and Beaumont, in some excitement, wrote to Wyndham: 'If the drawings keep up to this standard it will not be long before your name blazes round England like beacons in Macaulay's poem on the Armada.'

Beaumont wrote histories, studies of dancers, ballets and companies, books on décor and puppetry, all while being a publisher and running his bookshop whose customers were treated with a leisurely courtesy and attention. But this was not all. In 1926, to develop certain of his ideas on dance, he founded

Design – Wyndham Payne

An illustration from *Town & Country: A Collection of Designs and Drawings by Wyndham Payne*, published by CW Beaumont, 1926. The book was published in two editions: 60 signed copies on handmade paper; and 250 on 'antique' paper.

* * *

(albeit briefly) The Cremorne Company, at a time in London when Ninette de Valois had only presented a small group of dancers 'on the halls' and Marie Rambert had not even given a pupil show. He engaged Wyndham to design the costumes and scenery for the ballets *The Christmas Tree* and *Circus*. Beaumont was delighted with the results, commenting on the designs for *The Christmas Tree* that, 'The first is fine and the latter is very beautiful indeed. I kept putting it back in the envelope & then taking it out again…'

The ballets were performed at the New Scala Theatre, Charlotte Street, London, on 11 March 1926, with Frederick Ashton making his debut, and later in the same year, on 29 November and 2 December at Dukes Rehearsal Theatre. The *Daily Sketch* featured photographs of Wyndham's costumes for Jessie Anderson as the Sailor Doll and Aileen Harries as the Little Match Girl in *The Christmas Tree*.

Beaumont probably had some influence in gaining Wyndham's commission in 1924 to design a cover for the music of *La Boutique Fantasque* for J. & W. Chester Ltd. Certainly, he was assiduous in urging accuracy on Wyndham by sending him photographs of dancers and costume designs of the production in October 1924. Wyndham made the suggested alterations, although the rough drawing for the cover is in many respects better than that published – the elements in much of the composition are stronger and the characterisation greater in wit and vitality.

* * *

In 1924 Wyndham and Dorothy purchased a substantial house, Waterden Cottage, on London Road in Guildford, Surrey, where they lived until 1931. From Guildford, Wyndham was able to travel easily by car, train or, in one case, 'motorised charabanc' to London each week, usually on a Tuesday. Wyndham loved motorcars. He drove a Buick when working for Huntley & Palmers on business and later, for himself, a Bean tourer. In 1924 he purchased his first Humber saloon and continued with this marque until unable to drive in 1939. His interest in cars went further than most, extending to maintaining and repairing them himself in a

* * *

rented nearby garage with an inspection pit. On arrival home after the completion of a journey, Wyndham would valet the car, even removing stones from the tyre treads.

The Paynes' social world revolved round family and local acquaintance with the occasional invitation from commercial friends to engage in metropolitan pleasures. Apart from Cyril Beaumont, Wyndham does not appear to have had contact with an artistic circle, perhaps because he had neither attended a London art school nor exhibited his work. He was not a member of the London Sketch Club nor the Art Workers' Guild, both of which afforded opportunities of intellectual and social companionship. But he did become a member of the Faculty of Arts in November 1924, and contributed numerous splendid illustrations to its journal, *The Orbit*, which was edited by Herbert Furst.

Wyndham and Dorothy delighted in decorating, arranging and rearranging the rooms of their home as their collection of furniture, pictures and china grew. His diary records a tranquil and loving family life:

Monday 6 February, 1928
'Took Paul for a walk in afternoon, bright sunshine all day but cold. These frequent walks with Paul will not last much longer now for soon he will be commencing school… I cannot help but feel that he will not forget the happy times he has spent with me in these walks.'

April 20, 1928
'Busy working in Studio during morning but cut the grass in front… Studio during afternoon when I completed the series of 6 Christmas Cards for Sharp's of Bradford – After tea playing cricket with Paul on the grass until I lofted the ball over the garden… which closed the innings…'

Wyndham loved making models for his son. He was interested in the concept of the pleasure of giving presents and was nostalgic for remembered excitement. In the case of one model he made of a locomotive and carriage in wood, card and wire all painted in bright shiny colour, boxed in gaily patterned paper, he comments:

* * *

Design – Wyndham Payne

In later life, when glaucoma limited his capacity for illustration, Payne created functioning painted models in wood, often for the entertainment of his grandchildren.

* * *

'This somewhat fantastic little device was not made as a toy to be played with & is therefore fixed in its box. The intention was that it should recall to "Grown-ups" something of their childhood delight in opening a box given as a present to find in all unused freshness a gaily painted toy.' It may be, as with other models he made – for example, boxes of soldiers or crackers – that it had a commercial intent.

Wyndham's studio was on the upper floor of Waterden Cottage, where he worked at a flat deal table beneath a window. The white walls were covered in designs and posters and the furniture simple: a well-stocked bookcase and a cupboard filled with all kinds of paper. His son remembers that the studio floor was always strewn with crumpled, abandoned drawings. He worked like a 'greyhound', very speedily producing drawings with a quill or fine pen, which if liked were put aside, otherwise he threw them to the floor. To Dorothy's irritation he wouldn't want the floor cleared except by himself. His son was allowed into the studio, but had to sit quietly. Evidently, the studio was not always a comfortable workplace; his diary entry for 14 January 1928 reads: 'It is impossible to write todays [sic] entry with ink as it is frozen solid in my inkwell... My studio work is at a complete standstill owing to the intense cold of my room...'

Always busy, he yet found time to indulge his fancy in schemes of seemingly little commercial worth. His charming paintings on glass were reported in the press; on 23 December 1933, *The Sphere* recorded:

> 'The Fascination of the Silhouette – A New Technique... the latest exponent of this method is Mr Wyndham Payne whose work is well known to readers of The Sphere Christmas Numbers. He has developed a silhouette technique on glass. The painting is done on the inner surface, and gold is here and there allowed to show through the fine lines. Mr Wyndham Payne frames the glass at a little distance from the back piece so that a slight shadow is thrown from the black silhouette on the glass.'

A 15-minute film about Wyndham's glass painting, entitled *Capturing Shadows (The Silhouette Art of Wyndham Payne)*, was made by Gaumont-British in 1934.

✱ ✱ ✱

In the basement, Wyndham kept a small nipping press for printing. He printed from wood and lino blocks and also experimented with pulls from textured papers and Japanese leathers which he found in what he called 'gubbins shops', that is junk shops. Beaumont wrote: '[Payne was] forever experimenting with materials; the effect of various colours on different papers, silks and leathers; the combination of one material with another.' Wyndham was an avid collector of patterned papers, textiles, scrap books (to the extent of advertising in the local paper for them), old paint boxes, pictures, ceramics and furniture. These he liked to display in the living rooms and in his studio, in a case resembling a shop window. He liked to show objects related in spirit or style and to add new finds and make rearrangements. He never bought from antique shops, preferring junk shops, and keeping many pieces for his collection, though much was sold on at auction.

His great coup of connoisseurship came in 1943, in Cirencester, where he spotted on the floor of a junk shop what is now known as The Wyndham Payne Crucifixion, a miniature on vellum from a missal, painted by H. Scheerre in the early fifteenth century. The dealer claimed that he had bought it from a local clergyman, thinking it a reproduction, and Wyndham bought it as such. Later, on 5 December 1973, it was purchased at Christie's with the aid of the National Art Collections Fund and The Pilgrim Trust, and is now in the British Library. Another important find was a John Constable watercolour bought at auction in Cheltenham in 1944: 'The Mill', after Rembrandt. The provenance of this painting was researched by Wyndham's son Paul and sold in 1998 for £90,000.

* * *

Wyndham sought commissions directly from publishers, calling on them on his weekly trips to London, but at first soliciting their interest by letter. On 9 August 1923, he wrote to The Bodley Head: 'I wonder if you are likely to be interested in an illustrated edition of "Robinson Crusoe"? If so I should be glad if you will consider the enclosed preliminary suggestions... I shall be pleased to submit further suggestions upon request.'

* * *

Design – Wyndham Payne

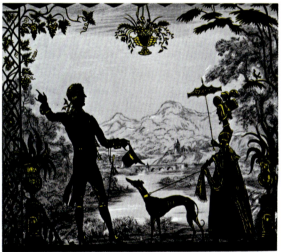

Paintings on glass; a silhouette was made on the inner surface of the glass, and then placed over the illustrated back piece. Above: *A Cup of Tea*; Below: *The Way to the Chateau*.

* * *

MEDDLESOME
MATTY
AND·OTHER·POEMS·FOR·INFANT·MINDS
by
JANE & ANNE TAYLOR

With an introduction by
EDITH SITWELL

Illustrated by Wyndham Payne

LONDON
Published by John Lane
The Bodley Head Limited
in Vigo Street. 1925.

The Bodley Head did not respond immediately so Wyndham wrote ten days later to enquire if the small parcel of designs had arrived. His persistence was successful, for by 25 August 1923, he wrote to Mr Willett, a manager at The Bodley Head, thanking him for a commission. Others followed in September for eight illustrations in their monthly magazine, The Bodleian, and a page of decorations which Wyndham felt would 'add greatly to the interest of the journal'. They did indeed. The Bodleian had been illustrated lately but rather solemnly. Wyndham's decorations added wit. Two fine pen-drawn endpieces, Impressions (February and March 1924) are particularly lively. The headpieces are taken from boldly cut wood or lino designs, which if signed are done with a capital 'P'.

Wyndham's drawings appeared often in The Bodleian in 1923 and until September 1924, while other commissions from The Bodley Head included designs for advertisements and book jackets. Wyndham wrote to Willett on 1 October 1923:

'I have pleasure in enclosing herewith a rough as a suggestion for the wrapper of "The Abbey Court Murder" together with a finished proof from the original blocks I have cut for this design – I have endeavoured to break away from the usual sensational style of jacket, & yet I feel that the design is arresting, with something of mystery about it, & a pleasing colour effect – If you [decide] on this design, I think it would be as well to have some printed from my blocks.'

Wyndham was assiduous in seeking work, sending press reviews to publishers and assuring them that future commissions would always be done 'to my very best for you in order to make it a success' (14 January 1925).

He also made direct approaches to authors, not always successfully, as is shown by the following extract from A.E. Coppard's letter dated 5 May 1927:

'Thank you very much for sending the 4 books – they are all so charming that it makes me regret my inability to fix up an arrangement with you. For some obscure reason I can only work reasonably well on themes that come spontaneously to me & I am quite dithered when asked to do something special or by a certain time.'

* * *

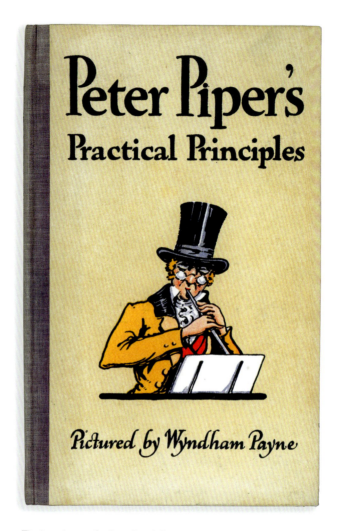

The board cover for *Peter Piper's Practical Principles (of Plain and Perfect Pronunciation)*, published by John Lane, The Bodley Head, 1926.

However, once a commission was secured, proof pages went back and forth and there could be detailed opinion from Wyndham on how the book should be made, such as the correspondence below relating to *Peter Piper*:

21 May 1926 to The Bodley Head:

'I am very much obliged to you for sending me the printer's specimen page for the "Peter Piper" book & I should like to make the following comments:- I do not think that the type used for the verse is sufficiently heavy & the effect is weak against the illustrations on the opposite page – A bolder type would "pad out" the somewhat sparse type script of the book & would of course be more legible for the use of the children – I think also that the verse should commence with a large initial letter, giving some indication that the verse runs through the Alphabet…' and much else concerning captions, continuing: 'The size of the book seems to me to be just right…'

The correspondence continued and on 14 August 1926 Wyndham wrote:

'Since, as I think you will agree the success of this book must rest largely with the attractiveness of the illustrations, I trust you will be able to send all the coloured proofs to me for approval. I am glad you have noted the necessity for the black to be the final printing, for if this is done it gives considerably more brilliancy to the other colours. I do not like the red used in the proofs… it is too brownish… and should be brighter by the addition of a little, but not too much, vermilion…' This gives a perspective on Cyril Beaumont's gentle but constant suggestions to Wyndham, particularly as in this case Wyndham was also the author. *Peter Piper's Practical Principles* (1926) turned out to be one of his most successful books, handsomely designed and with good sized illustrations that delighted reviewers, such as *John O'London's Weekly*, which commented: 'These amusing pictures should delight all children.'

* * *

It would be an error to think that Wyndham's work in small illustrations using black line over one or two colours was his most successful. True, his small line drawings enhance the intimacy of much of his work, but he was equally effective in his larger, vigorously cut blocks for *The Orbit* and *Town & Country*, and his designs for book jackets. *The Barbury Witch* (1927) book jacket is in the style of his vignettes in black line over green on white paper, while *All A-Blowing* (1927) has a gorblimey flower seller drawn in fittingly rumbustious wide brush strokes. For *Trefoil* (1923), he cut a strong naturalistic design of embracing lovers against a forest edge in black over green and white, while his cover for *The Abbey Court Murder* (1923) used dramatic near abstraction.

Wyndham suffered the usual frustrations of the artist, noting in his diary on 7 March 1929 that 'one never can tell the likes & doubts of a publisher and it's more than likely some alterations will be required which will spoil the freshness of the original conception…' However, there were also occasional joys, such as a letter from Nancy Morrison to Lord Gorell on 9 January 1931, which stated: 'I am simply delighted with my cover [for *Solitaire*, 1932], it is so charming, and by far and away the cleverest and most arresting "jacket" I have seen. The artist has done it beautifully. I am so pleased with it…'

Wyndham designed three book jackets for The Bodley Head in 1923; nine in 1924, and by 1930 a total of twenty-one. He was paid £3.3.0 for each one. Intriguingly, they paid him £4.4.0 for four Poster Stamps (as yet untraced). The Chelsea Publishing Company and Grant Richards also commissioned two jackets each in 1923. There may be other undiscovered jacket designs as well, but he is known to have produced eighteen for John Murray; three for Constable and Geoffrey Bles; two for The Medici Society, and at least one for the following publishers: Nelson, Pulman, Putnam, Methuen, Simkin, Marshall, Oxford University Press, Associated Newspapers, Kingsley, Harrap and Hodder & Stoughton.

Throughout his career, Wyndham was very busy with illustrations for magazines and with designing calendars, Christmas cards, menu covers, catalogue covers, letter heads, trade cards and small advertisements – some were of a refined elegance while others

* * *

Design – Wyndham Payne

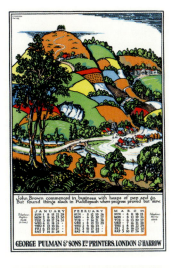
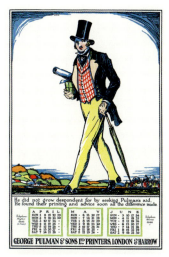
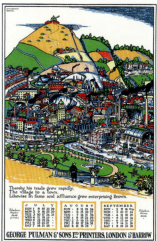
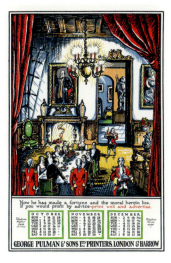

Pages from a large-format calendar, produced to market the services of the printer, George Pulman & Sons.

✦ ✦ ✦

were led by his observational humour, charging the design. A change of address card for Bishop & Sons, Belgrave Road, London, is a wonderful example: a silent film comedic scenario of near disaster for the header and a careering horse-drawn pantechnicon for the footer. A personal delight in festivals, present giving, family feasts and party games with their gentle absurdities (Wyndham liked to sing and perform conjuring tricks at such occasions) gave a sincerity to his greetings cards for The Medici Society. Unfortunately, surviving examples of his commercial work are seldom dated.

For his commercial work, Wyndham employed the services of an agent, Sharmid (to become Middleton in 1934) of 6 Wells Street, Piccadilly, who was very active on his behalf. Yet, despite their efficiency, he suffered the traditional doubts and difficulties of his trade – his income was not steady. Such records as survive are fragmentary:

25 October 1928
'... our finances... the position is none too satisfactory for the main reason that people pay for my work so slowly. I have outstanding amounts dating back 6 to 8 months & it makes things very difficult at times...'

24 January 1929
'... By investigating my accounts, I find that I made £309.7.7 last year from my art work, which altho' far from what I hope to attain is satisfactory. My agent accounted for £214 of this sum & John Lane £71. I hope to accomplish far greater things this year which is the object of my collecting specimens of my latest work with which I shall hope to open up fresh outlets.'

25 January 1929
'Cheque for £6.7.6 to hand for work for *The Evening News*...'

On 29 March that year, his diary tells us that some financial stability was achieved following a meeting with Mr Milne of Henry Stone & Co. of Banbury, who offered Wyndham a post at a salary of £500 a year plus 25% commission on all work

* * *

accepted. He officially began to work with them on 1 May, but it is not known how long the association lasted or what the exact nature of the connection was, as his diary entries peter out in late 1929. But, whatever it may have been, he continued to work from home for them and also his existing clients:

14 June
'Up to London... I went to the Medici Society & spent the rest of the morning... discussing work for calendars, Christmas cards & book decorations. I came away with a quantity of work... which will keep me busy for a good time.'

29 June
'Received with much pleasure my Second Salary Cheque from Henry Stone for £41.3.4 together with £4.19.9 commission on work accepted...'

* * *

In 1937, Wyndham was employed as art advisor to Trinidad Leaseholds. And in that same year, in one of a number of moves after leaving Waterden Cottage in 1931, he purchased Tivoli House in Cheltenham. With the onset of glaucoma in 1938, he found it increasingly difficult to execute fine and detailed work, and so retired. Nevertheless, he saw an active home role in the coming war. In 1939 he was appointed Flight Lieutenant and Adjutant, 125 (Cheltenham) Squadron Air Defence Cadet Corps, and in 1941, Squadron Leader, commanding 175 (Cheltenham) Squadron, Air Training Corps.

Wyndham's last book was *The Wife of Wellington* (1943) by Maud, Duchess of Wellington, who was delighted with his work. On 19 October 1942, she wrote:

'*I love the picture of the Duchess Kitty in the gold frame. The likeness is quite good enough. You have made her an enchanting... child which is exactly what I want. The grace of this little picture is indescribable. She haunts me. I feel so anxious to have it in Book Form. Whatever other Fate might be in store for it. Books and Lovely drawings Last... Thank you again with all my heart for the perfect pictures.*'

* * *

Another letter followed, on 26 July 1943: '…There was a Notice about it in The Daily Telegraph some days ago, and famous folk have copies of it in their possession. They all say "The illustrations make the Book" – and I heartily and emphatically agree.'

Not surprisingly, the notice in the Daily Telegraph and Morning Post for 16 July 1943, was a little less effusive: 'Mr Wyndham Payne provides some attractive "decorations" for this beautifully produced book.'

Finally settling in Sidmouth, Devon in 1965, Wyndham and Dorothy continued their interests in collecting – visiting gubbins shops and dealing. He died there in 1974.

William Connelly

* * *

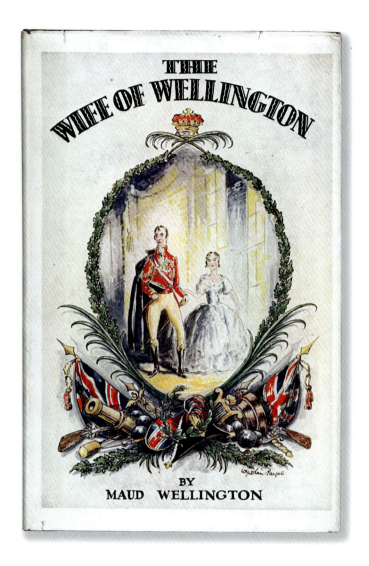

The Wife of Wellington: A Fantasy Founded on Fact and Treated with Liberty, A.&C. Black Ltd, 1943. The dust jacket concealed a burgundy cloth board stamped with gold foil.

Design – Wyndham Payne

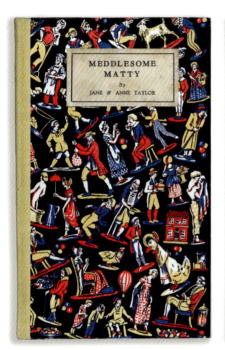
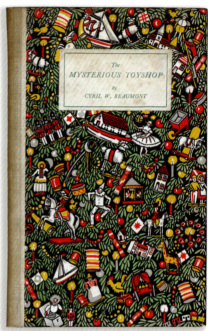

'It makes my blood run cold to think of our daily falls from righteousness,' wrote Edith Sitwell in the introduction to this 1924 edition of *Meddlesome Matty*. In the same year, *The Mysterious Toyshop: A Fairy Tale* was written, published, typeset and bound by Cyril W. Beaumont.

Design – Wyndham Payne

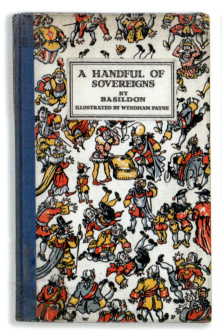 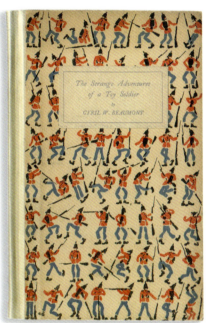

A Handful of Sovereigns by Basildon, published by The Medici Society, London, 1930, presented a collection of illustrated poems on English monarchs. The print run for *The Strange Adventures of a Toy Soldier*, 1926, included a special edition of 110 numbered copies printed on Japanese vellum.

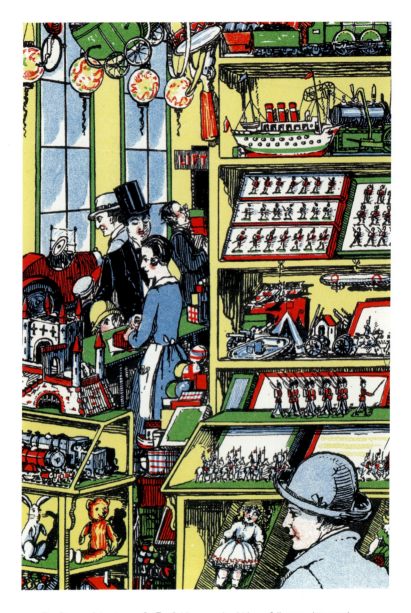

The Strange Adventures of a Toy Soldier promised 'three full-page plates and fourteen decorations in the text designed by Wyndham Payne'.

Design – Wyndham Payne

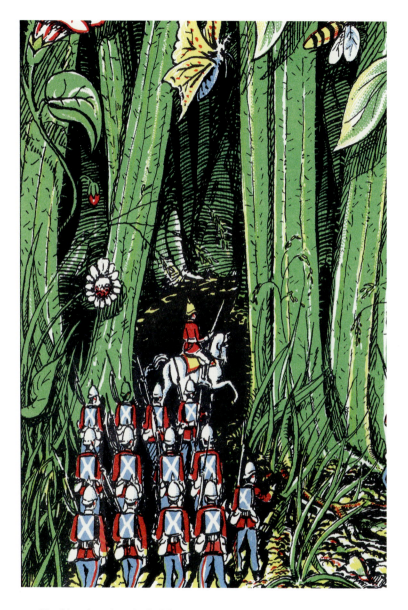

The fairy tale, written by Cyril Beaumont, included the soldier's encounters with wild animals and unknown birds, and the exploration of a 'savage jungle'.

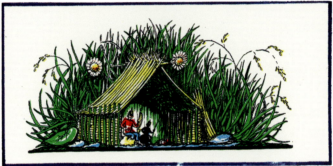

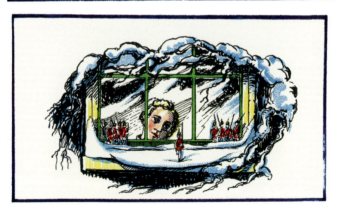

Decoration for *The Toy Soldier* (above), Payne's rendering of a sinking steamship (opposite) took inspiration from the toy boats of German manufacturers Bing and Märklin.

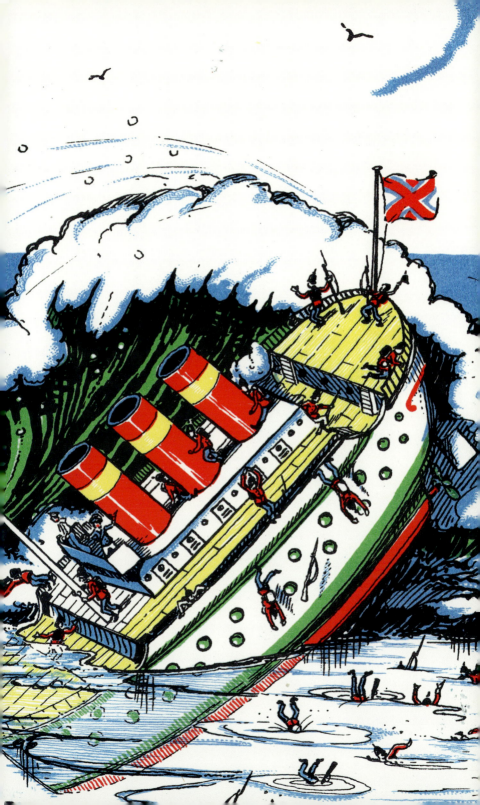

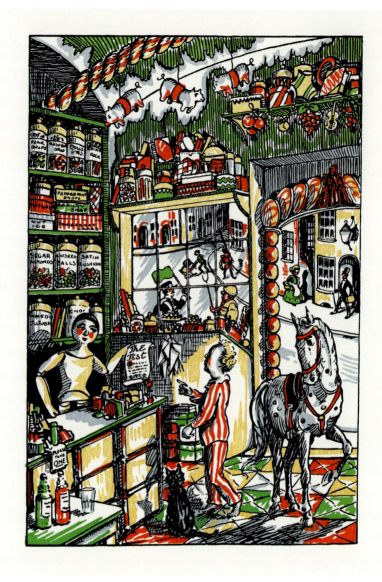

The Wonderful Journey: A Fairy Tale was extensively illustrated, featuring nine colour plates and 40 black and white sketches.

Design – Wyndham Payne

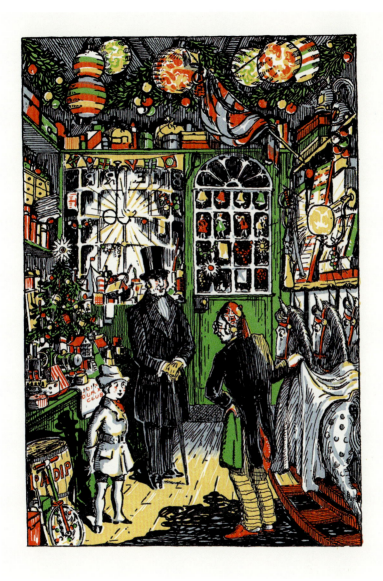

The print run for the book included a special edition of 110 numbered copies, each signed by Payne and the author, Cyril Beaumont.

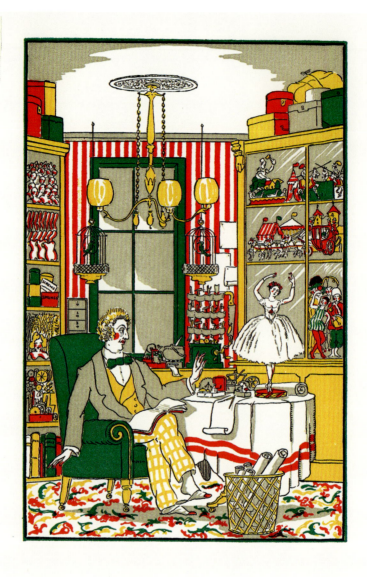

'It was a fortnight before Christmas, and every one agreed that this would be a real Christmas'; so began *The Mysterious Toyshop: A Fairy Tale*.

Design – Wyndham Payne

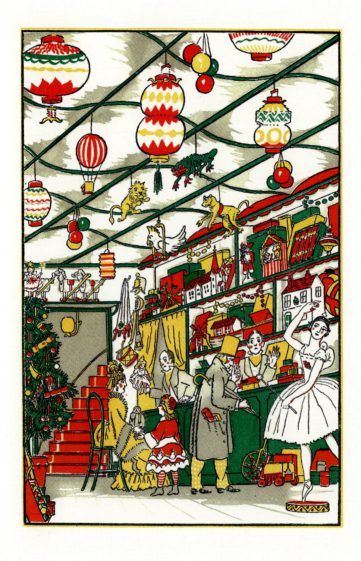

The book, published in 1924, was Payne's second collaboration with Charing Cross Road publisher Cyril Beaumont. Several more would follow.

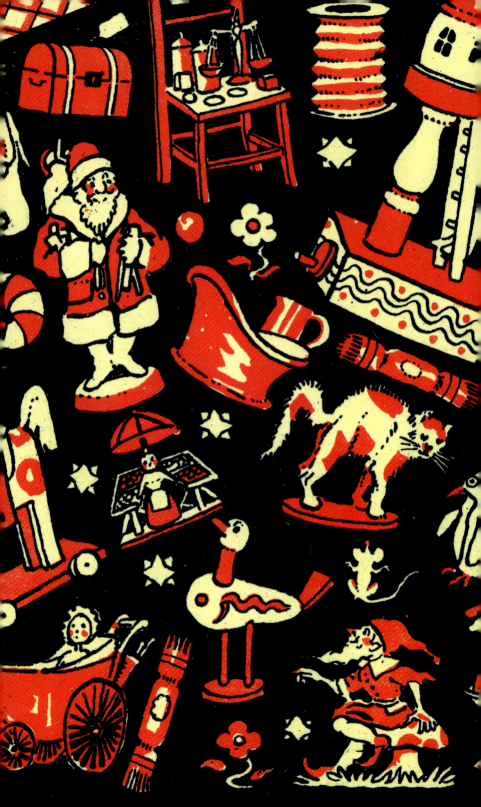

Design – Wyndham Payne

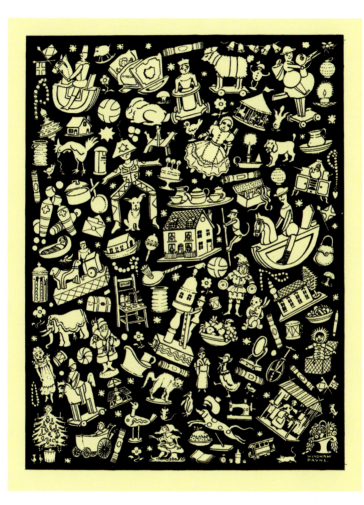

Proofs of pattern papers featuring popular Payne themes – toys and Christmas.

Design – Wyndham Payne

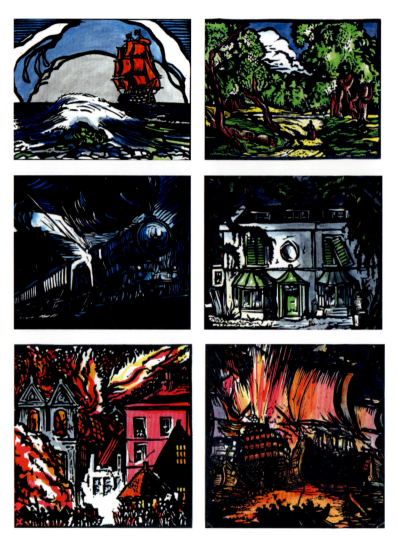

Hand-coloured illustrations from *Town & Country: A Collection of Designs and Drawings by Wyndham Payne*, 1926. Clockwise from top left: *Homeward Bound; The Woodland Path; Desolate Splendour; Sea Fight; Fire! Fire!! Fire!!!; The Night Train.*

Design – Wyndham Payne

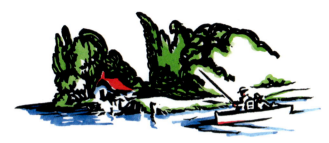

The Weir Pool

Winter in the Country

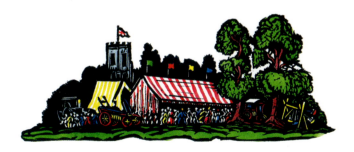

The Country Fair

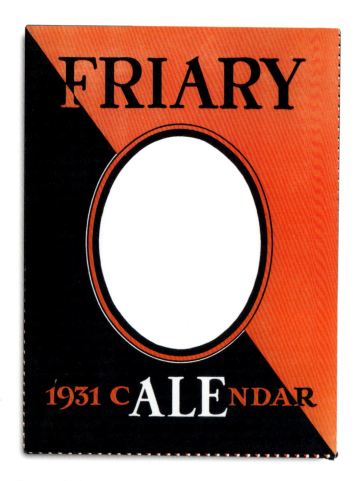

Payne acquired several commissions through the Stuart Advertising Agency that included Edward Bawden, Ben Nicholson and Barbara Hepworth amongst its commissioned artists.

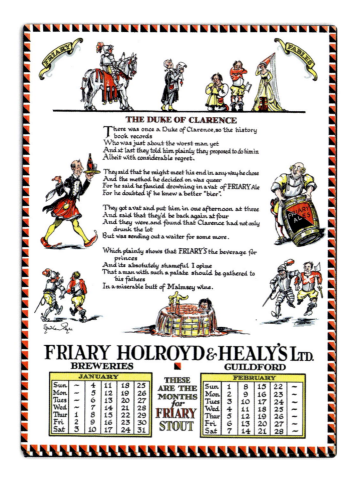

In 1931 he illustrated a calendar for Friary Ale, brewed by Friary, Holroyd & Healy's of Guildford. Each two-month page featured a poem and several amusing vignettes.

Design – Wyndham Payne

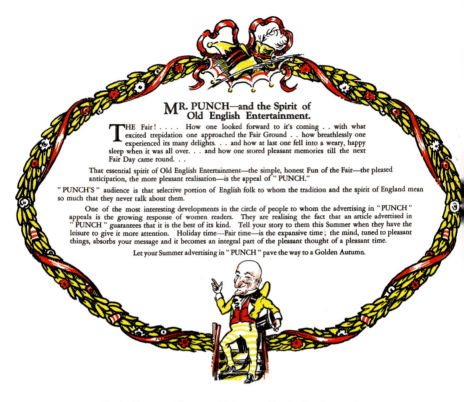

The inside spread from a publicity pamphlet for *Punch* magazine enticed luxury brands to advertise in the journal. In particular, the magazine was pitching to advertisers trying to attract female customers, declaring: 'Our advertisers find that their luxury appeal story is heard and responded to by "Punch's" women readers.'

Design – Wyndham Payne

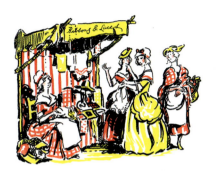 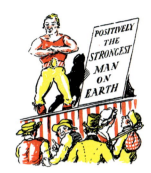

THE strong man at the Fair was the admired of all beholders—the men of the "PUNCH" public are the admired of the world because they are the cultured, perceptive, discerning, best-of-England type that by tradition buys the best only.

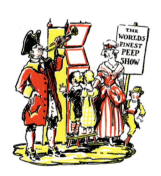 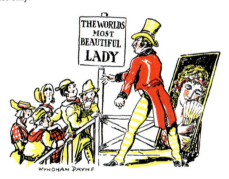

STRANGE and wonderful things were seen in the Fair Peep Show . . .

Design – Wyndham Payne

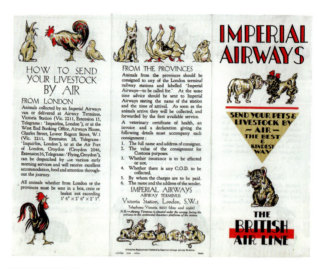

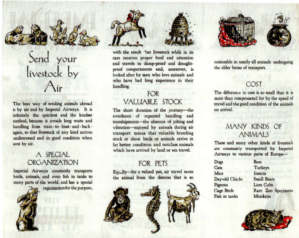

Pamphlet and printed sheet produced in 1931 for Imperial Airways, 'the British Air Line', through the Stuart Advertising Agency, promoting their service for sending pets and livestock by air. The pamphlet lists animals for transit: dogs, day-old chicks, mice, fish in tanks, bees, small bears, lion cubs, rare zoo specimens and monkeys. Not to mention seahorses.

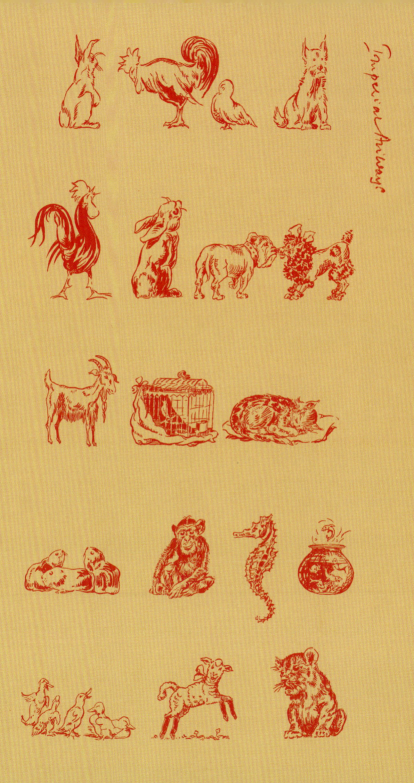

Design – Wyndham Payne

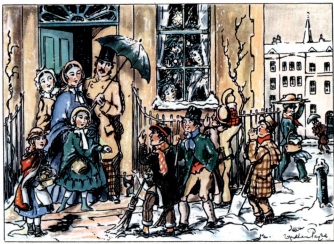

Payne illustrated Christmas cards for The Medici Society, established in 1908 to offer art 'for the lowest price commercially possible'.

Design – Wyndham Payne

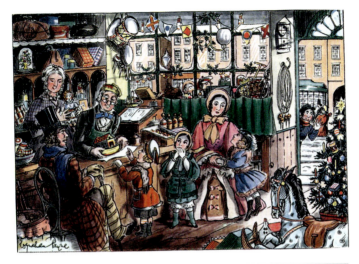

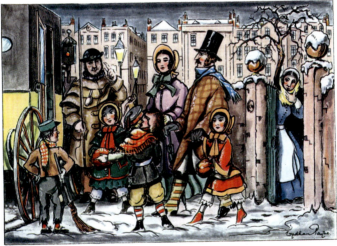

On the inside, the cards are generally credited to the illustrator: 'After the water-colour drawing by Wyndham Payne'.

The cover proof (with the title and author removed) for the book *Policing the Top of the World* by H.P. Lee, 1928; featuring the reminiscences of a Canadian mountie.

Design – Wyndham Payne

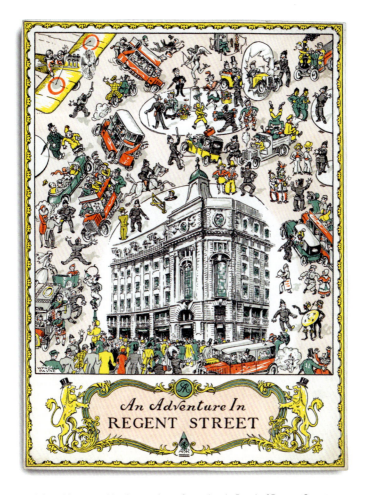

Advertising pamphlet for men's outfitter, Austin Reed of Regent Street. The cover shows the central London store; the insides depict a cross-section of the building (overleaf).

Design – Wyndham Payne

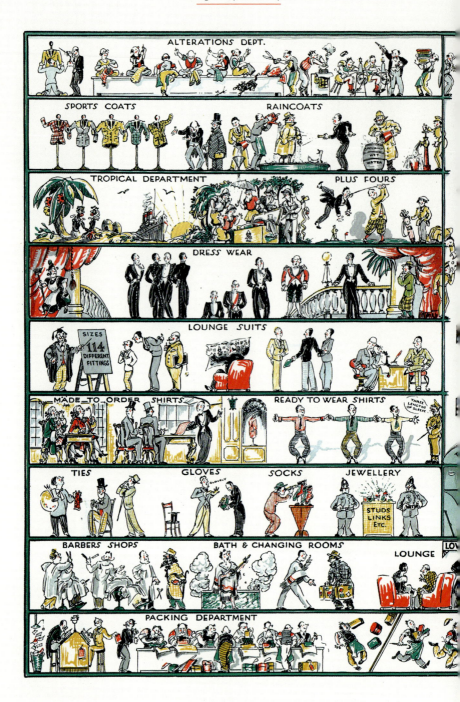

Design – Wyndham Payne

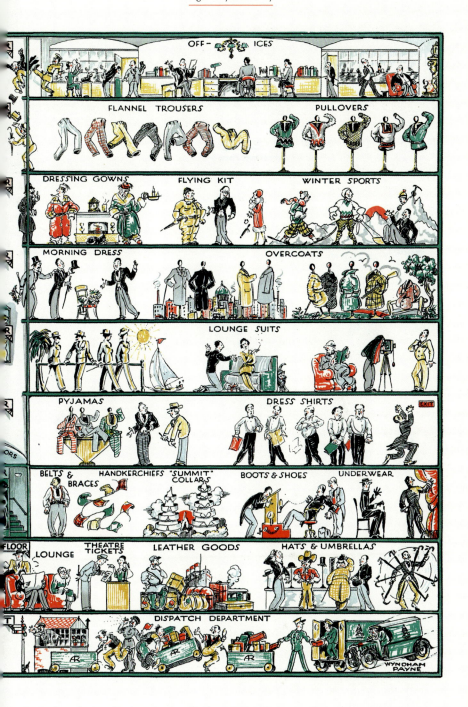

Design – Wyndham Payne

A much-patched book jacket printed-proof illustration for *All A-Blowing* by F.W. Thomas, published by G.P. Putnam & Sons in 1927.

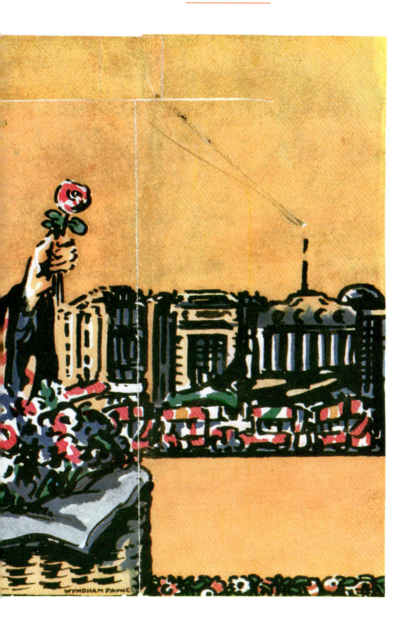

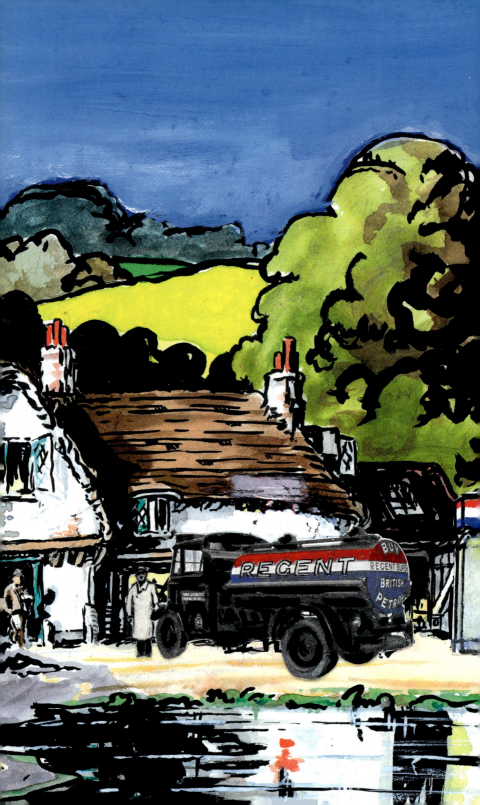

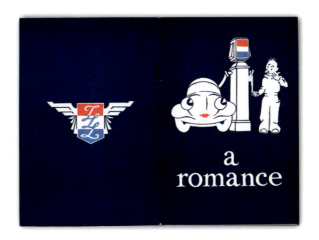

 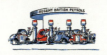

Promotional collage and 16-page booklet, *A Romance*. Created for Regent Petrol, produced 'in the most modern refineries in the British Empire'.

Design – Wyndham Payne

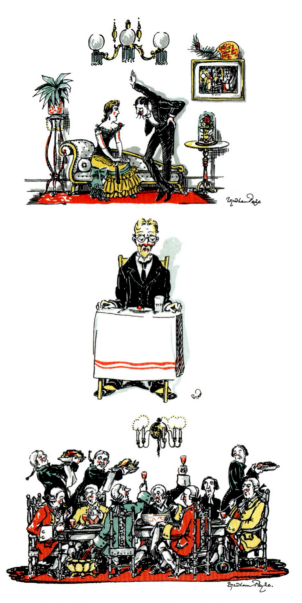

Series of humorous pen and ink drawings from the early 1930s.

Design – Wyndham Payne

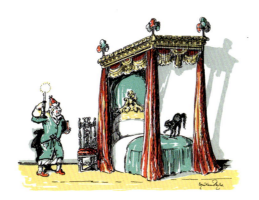

Created for a book of poetry by Basildon, published by The Medici Society.

Design – Wyndham Payne

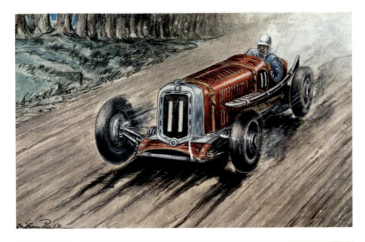

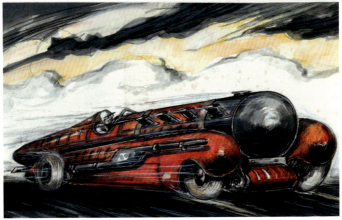

Work in mixed media, produced for Regent Petrol.

Design – Wyndham Payne

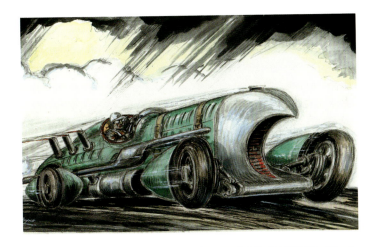

All four artworks were created in 1937/1938.

Design – Wyndham Payne

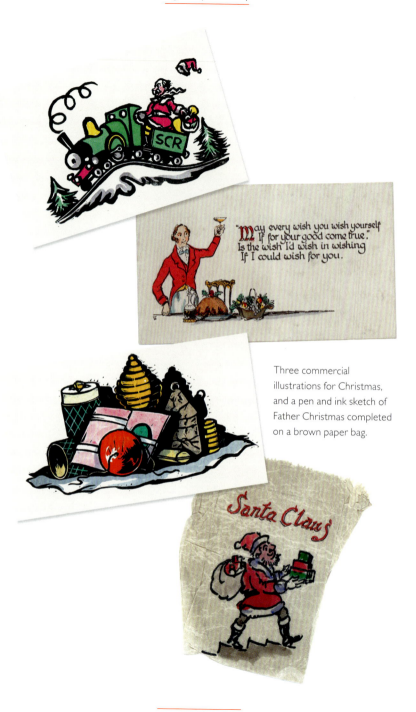

Three commercial illustrations for Christmas, and a pen and ink sketch of Father Christmas completed on a brown paper bag.

Design – Wyndham Payne

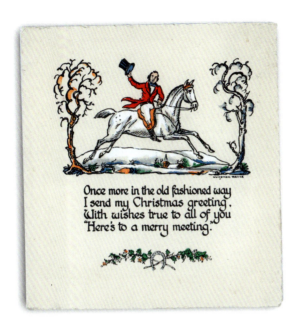

Payne created seasonal cards – for Christmas and Easter – throughout much of his career. The country gentleman was a recurrent character.

Design – Wyndham Payne

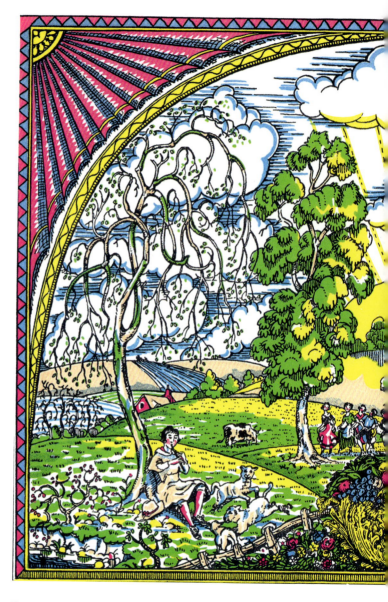

The top half of a calendar, showing the seasons; mounted on card,
originally with the months of the year hanging underneath the illustration.

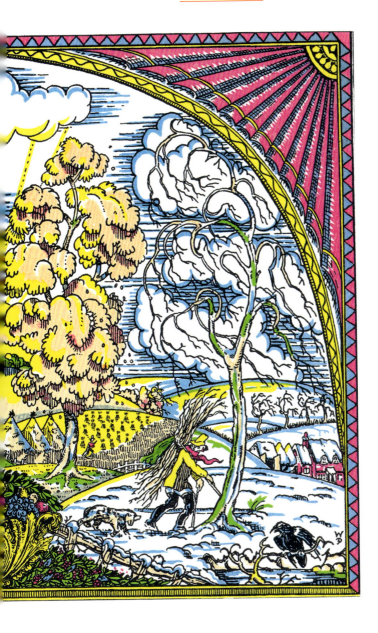

Design – Wyndham Payne

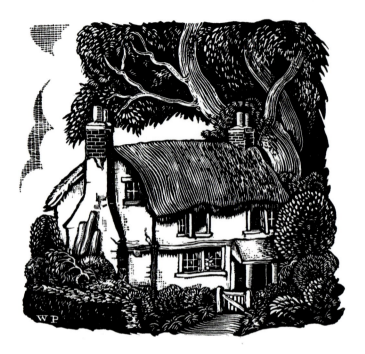

Above: Christmas card annotated, 'The Woodman's Cottage, wood engraving by Wyndham Payne'; below: illustration from a Christmas card, dated 1936. Opposite, top: cover illustration from *Ghosties and Ghoulies* by Francis C. Prevot, Chelsea Publishing Company, 1923; opposite, bottom: illustration for a greetings card.

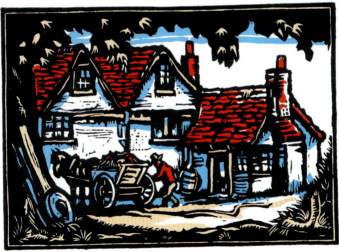

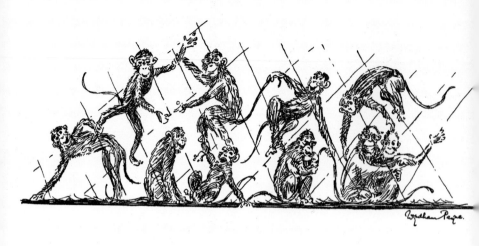

Five-and-twenty monkeys
Playing in the Zoo;
Half-a-dozen people,
Laugh at what they do.

Half-a-dozen people,
Slowly walking out,
The joke's as good as ever,
The other way about.

 B. DONNE SMITH.

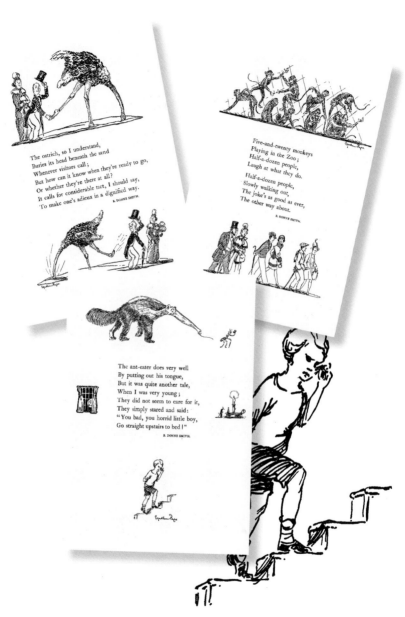

Illustrations for animal-themed poems by B. Donne Smith.

Design – Wyndham Payne

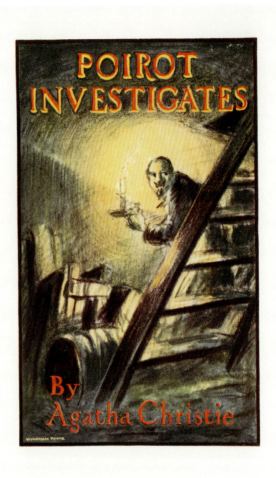

Cover illustration for the 1924 edition of *Poirot Investigates* by Agatha Christie, published by John Lane, The Bodley Head.

Design – Wyndham Payne

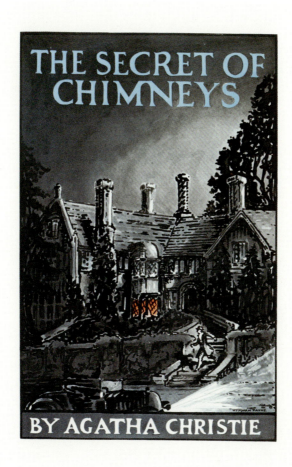

Cover illustration for the second edition of *The Secret of Chimneys* by Agatha Christie, published by John Lane, The Bodley Head, 1928.

Design – Wyndham Payne

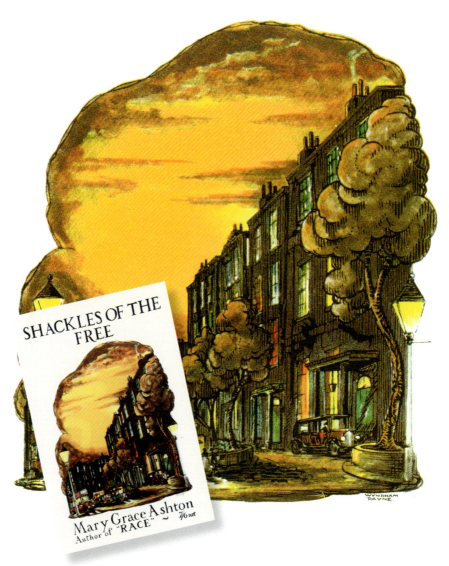

Cover illustration for *Shackles of the Free* by Mary Grace Ashton, published by John Murray, London, 1928.

Design – Wyndham Payne

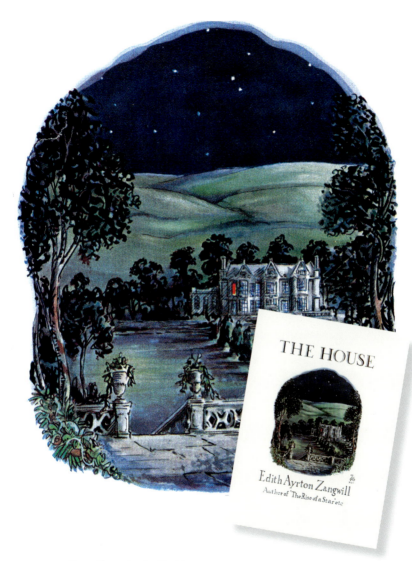

Cover illustration for *The House* by Edith Ayrton Zangwill, published by John Murray, London, 1928.

Design – Wyndham Payne

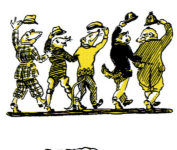

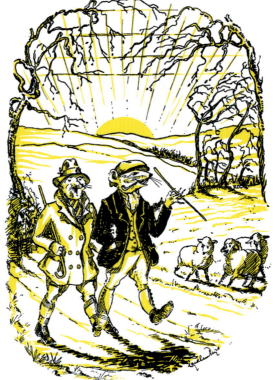

THEY WERE RETURNING ACROSS COUNTRY

Payne illustrated the 1927 edition of *The Wind in the Willows*, published by Methuen & Co. Ltd, of 36 Essex Street, London.

THE WIND IN THE WILLOWS
KENNETH GRAHAME

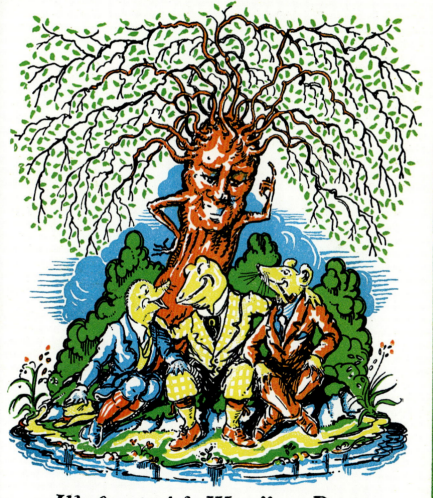

Illustrated by Wyndham Payne

Design – Wyndham Payne

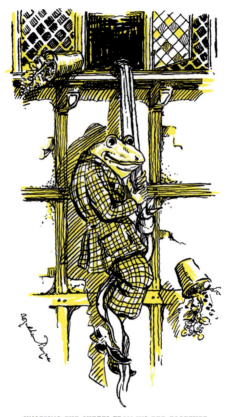

KNOTTING THE SHEETS FROM HIS BED TOGETHER
... TOAD SLID LIGHTLY TO THE GROUND

Payne produced 20 full-page colour illustrations for *The Wind in the Willows*. The well-known printers Butler & Tanner, of Frome and London, printed the book.

Design – Wyndham Payne

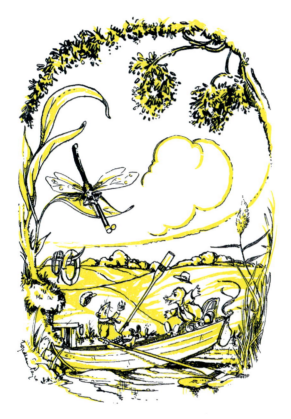

THE BOAT STRUCK THE BANK FULL TILT

Payne was the third artist (and the first British) to illustrate Grahame's book. He may have taken inspiration from Huntley & Palmers' biscuit tins (see page 6).

DAVID DOLLDRUM

D AVID DOLLDRUM DREAM'D HE DROVE A DRAGON:

DID DAVID DOLLDRUM DREAM HE DROVE A DRAGON?

IF DAVID DOLLDRUM DREAM'D HE DROVE A DRAGON,

WHERE'S THE DRAGON DAVID DOLLDRUM DREAM'D HE DROVE?

PETER PIPER

Peter Piper pick'd a peck of pepper:

Did Peter Piper pick a peck of pepper?

If Peter Piper pick'd a peck of pepper,

Where's the peck of pepper Peter Piper pick'd?

Two entries from the alphabetised, tongue-twisting *Peter Piper's Practical Principles (of Plain and Perfect Pronunciation)*, published by John Lane, The Bodley Head, 1926.

Design – Wyndham Payne

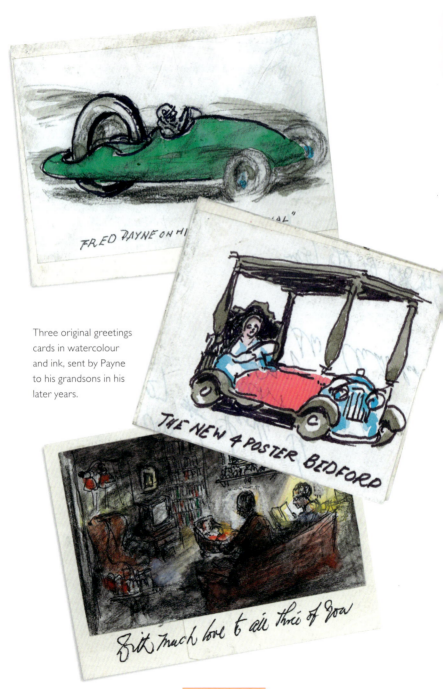

Three original greetings cards in watercolour and ink, sent by Payne to his grandsons in his later years.

Design – Wyndham Payne

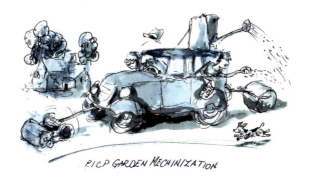

Original sketches in biro and watercolour on paper, including a Heath Robinson-esque design for the ultimate lawn-care machine.

Design – Wyndham Payne

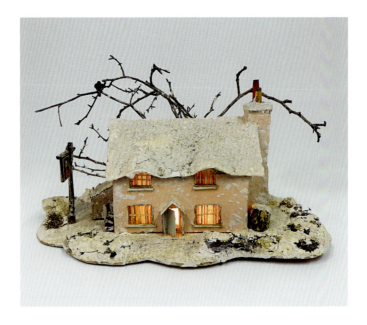

Afterword

The clearest recollections I have of my grandfather, Wyndham, 'the Old Rogue' as my parents called him, are from the last few visits when I was nine years old. He seemed tall, too thin; wearing a traditional jacket and tie, with thick-lensed glasses, pipe in mouth.

He would draw on paper, a few lines that came together; a few more horizontal lines were added and it became a railway track with telegraph poles, disappearing into the horizon. He always had an eye for a good idea, and for using it in his own way. Often, he found inspiration rummaging in junk shops.

He would make 'surprises' for our visits, models that 'did things' – they rocked, lit up, or even bellowed smoke from chimneys.

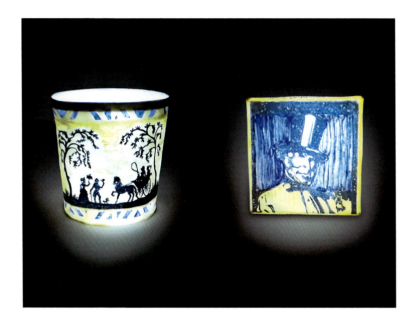

As a ceramicist, I have taken inspiration directly from my grandfather's work, shaping lampshades and lanterns that incorporate illustrations by Wyndham (see above); creating three-dimensional forms from flat sheets of glass fibre hand-painted with porcelain slip, the layers laminated together like filo dough. When lit, decorations painted between the layers or embossed on the surface are revealed.

It is my hope that my own artwork, this book and other resources – including an extensive archive at the V&A in London – will re-ignite an interest in Wyndham and his work.

Paul Payne

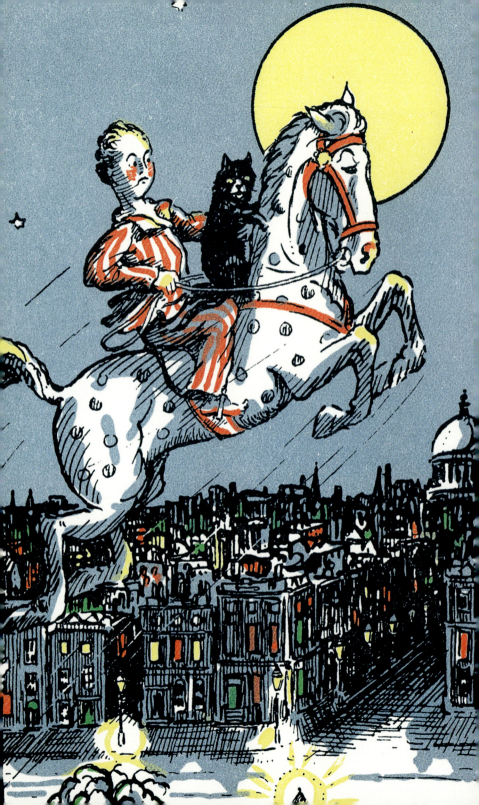

Words on Wyndham

'[Payne was] forever experimenting with materials; the effect of various colours on different papers, silks and leathers; the combination of one material with another.'
Cyril Beaumont, publisher

'[Claud Lovat] Fraser's natural successor was Wyndham Payne, whose colourful and lively illustrations for Bodley Head had all the vigour of Fraser's "cuts" whilst giving an added dimension through the sparing use of texture.'
Dr Ian Rogerson, Claud Lovat Fraser: A Catalogue,
Manchester Metropolitan University Library

'Payne's contribution [to The Wind in the Willows] was to place the characters in unmistakably English countryside. His inspired conception of Toad's canary-yellow caravan has remained through all ensuing illustrations... the artist's irreverent approach proved liberating.'
Selma G. Lanes (children's author), Through the Looking Glass

'I found my first Wyndham Payne book in 1974 in Newark market hall's second-hand bookstall. The illustrations in The Wonderful Journey fascinated me; the combination of magical dream scenes with bright 1920s colour and rather oddly drawn characters gave an intriguing impression of delight and menace, and this mixture caught my imagination. My enthusiasm has remained as my collection has grown.'
Kate Colyer, collector

'AWP, my grandfather, had the most wonderful mind. Apart from his own work, he had a perfect eye for the work of others. The British Museum, the Museum of London and the Ashmolean all have artefacts found and donated by and for him. He once spotted and bought a Constable watercolour in a junk shop in Cheltenham.'
Brian Payne

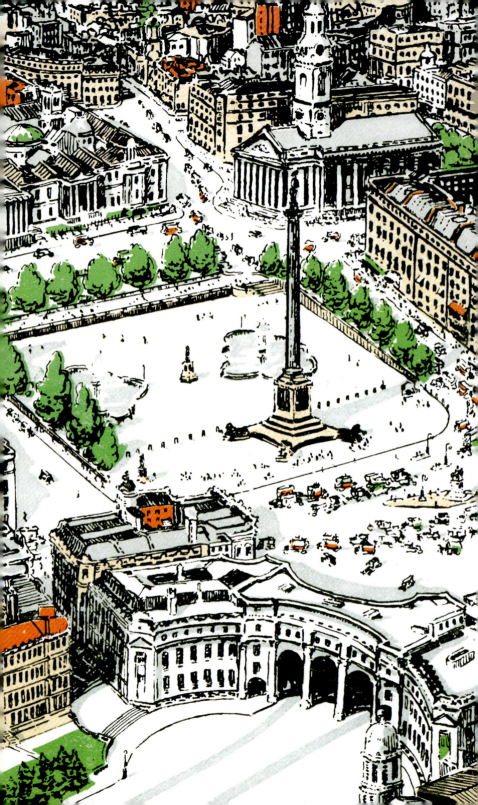

List of Works

A large collection of Wyndham Payne's work and related material (twenty boxes) was presented to the Victoria and Albert Museum by his son, Paul Payne, and is housed at the Archive of Art and Design, Blythe Road, London W14 OQX. The following incomplete list is largely drawn from that material. Additionally, Greenway in Devon holds Agatha Christie books illustrated by Wyndham Payne.

BOOKS

Poems from the Fireside, Dorothy C. Payne, 1917 (cover)
Within the Gates, Dolores Charlotte Frederica Harding, 1921 (jacket)
Ghosties and Ghoulies, Francis C. Prevot, 1923 (illustrations)
Adelphi, Francis C. Prevot, 1923 (cover)
The Blind Bow-Boy, Carl Van Vechten, 1923 (jacket)
The Dark Tide, Vera Brittain, 1923 (jacket)
The Chaste Diana, E. Barrington, 1923 (jacket)
Yasodhara, Nellie B. Badcock, 1923 (jacket)
The Abbey Court Murder, Annie Haynes, 1923 (jacket)
Trefoil, Mrs Fred Reynolds, 1923 (jacket)
The Book of Orchids, W.H. White, 1923 (jacket)
The Puppet Master, Robert Gruntal Nathan, 1924 (illustrations)
A Burmese Pwè at Wembley, Cyril William Beaumont, 1924 (illustrations)
The Hand of Glory and Further Grandfather Tales and Legends of Highwaymen, John Fairfax-Blakeborough, 1924 (illustrations)
The Mysterious Toyshop, Cyril William Beaumont, 1924 (illustrations)
Life on the Iron Road, Henry Chappell, 1924 (jacket)
The Next Corner, Dudley Carew, 1924 (jacket)
The Perilous Transactions of Mr Collin, Frank Heller, 1924 (jacket)
The Mauleverer Murders, A.C. Fox-Davies, 1924 (jacket)
The Secret of Greylands, Annie Haynes, [1924] (jacket)
Capitol Hill, Harvey Fergusson, [1924] (jacket)
The House by the Road, Charles J. Dutton, [1924] (jacket)
Poirot Investigates, Agatha Christie, [1924] (jacket)
Meddlesome Matty, Janet & Anne Taylor, 1925 (illustrations)

Previous page: from *The Wonderful Journey*; this page: Trafalgar Square.

Shelley and Keats as They Struck Their Contemporaries, Edmund Blunden, 1925 (cover, title page)
Near London, Marcus Woodward, 1925 (jacket)
Cricket. An Anthology for Cricketers, Samuel Joseph Looker, 1925 (jacket)
The Secret Road, John Ferguson, 1925 (jacket)
The Strange Adventures of a Toy Soldier, Cyril William Beaumont, 1926 (illustrations)
Parisian Nights, Arthur Symons, 1926 (illustrations)
Town & Country, Cyril William Beaumont, 1926 (illustrations)
Peter Piper's Practical Principles, John Lane, The Bodley Head, 1926 (illustrations)
Mrs Strang's Annual for Children, Humphrey Milford/Oxford University Press, 1926 ('Good for Nothing', Margaret Baker, 5 text illustrations)
The Great Book for Children, Humphrey Milford/Oxford University Press, 1926
The Jolly Book, Nelson, 1926 (endpapers)
The Red Book for Boys, Oxford University Press, 1926 (cover)
Adventures in Contentment, David Grayson, 1926 (jacket)
Angling Jaunts and Jottings, W.G. Clifford, 1926 (jacket)
Pages in Waiting, James Milne, 1926 (jacket)
The Whispering Gallery, Hesketh Pearson, 1926 (jacket)
The Streets of London, Gertrude Burford Rawlings, 1926 (jacket)
The House, Richmal Crompton, 1926 (jacket)
What Price Glory, John Foster Fraser, 1926 (cover)
The Wonderful Journey, Cyril William Beaumont, 1927 (illustrations)
The Wind in the Willows, Kenneth Grahame, 1927 (illustrations)
The Oxford Annual for Children, Edited Mrs Herbert Strang, 1927 (illustrations)
Marie Bonifas, Jacques de Lacretelle, 1927 (jacket)
The Barbury Witch, Anthony Richardson, 1927 (jacket)
Recollections of a Boxing Referee, Joe Palmer, 1927 (jacket)
Whispering Lodge, Sinclair Murray, 1927 (jacket)
The Winds of March, Halliwell Sutcliffe, 1927 (jacket)
The Sun in Splendour, Thomas Burton, 1927 (jacket)
Race, Mary Grace Ashton, 1927
The Gates of Delight, George Woden, 1927
All A-Blowing, F.W. Thomas, 1927
The Laws of Chance, F.E. Mills Young, 1927
The Bodley Head Christmas List, 1927 (cover)
The Best Jewish Stories, The Richards Press [1927]

The Best Railway Stories, The Richards Press, 1927
Sea Magic, Cyril William Beaumont, 1928 (illustrations)
The House, Edith Ayrton Zangwill, 1928 (jacket)
Policing the Top of the World, H.P. Lee, 1928 (jacket)
The Marloe Mansions Murder, Adam Gordon Macleod, 1928 (jacket)
The Secret of Chimneys, Agatha Christie, 1928 (jacket)
Shackles of the Free, Mary Grace Ashton, 1928 (jacket)
His Elizabeth, Elswyth Thane, 1928 (jacket)
A Garland of Perennials, 1929 (illustrations)
Children of the Moon. A Booklet Concerning Cats, Moira Meighn, 1929 (illustrations)
The Sound of the Horn, 1929 (illustrations)
The Surprising Adventures of Baron Munchausen, The Medici Society, 1929
The Friendly Road, David Grayson, 1929 (jacket)
Red Silence, Kathleen Norris, 1929 (jacket)
The Sanfield Scandal, Richard Keverne, 1929 (jacket)
A Handful of Sovereigns, Basildon (pseud.), 1930 (illustrations)
All Ways by Airways, H. Stuart Menzies, 1930
The Happy Glutton, Alin Laubreaux, 1931 (cover)
The Escapes of Captain O'Brien R.N. 1804-1808, A.J. Evans, 1932 (illustrations)
Solitaire, N. Brysson Morrison, 1932 (jacket)
The Polo Ground Mystery, Robin Forsythe, 1932 (jacket)
The Children's Circus Book, 1935 (illustrations)
The Peacock Pattern, Allan Govan, 1935 (jacket)
Flower Pot End, R.H. Mottram, 1935 (jacket)
Ordeal at Lucknow, Michael Joyce, 1938 (jacket)
The Wife of Wellington, Maud Wellington, 1943 (illustrations)
A Touch of Class: The Story of Austin Reed, Berry Ritchie, 1990

MAGAZINES/JOURNALS
Type, Number Seven, The Morland Press, 1923
The Bodleian, John Lane, Sept–Dec [1923?], Jan–Sept 1924
Brumaire, the Journal of F. & E. Stonham Ltd, Booksellers, Oct 1925
The Orbit (Journal of the Faculty of Arts), Jan, Feb, March, April, May, June 1926
The Orbit (Journal of the Faculty of Arts), 1927
The Sphere, 21 November 1927
Graphic, Christmas Number, 1927
The Orbit (Journal of the Faculty of Arts), 1928

The Sphere, June 1928
Eve, 'The Spirit of Christmas', Nov 1928
The Oxford Annual for Children, 'The Toll Keeper's Three Daughters', 1928
The Sphere, June 1929
The Sphere, Nov 1931
The Sphere, Nov and Dec 1933
London: *Associated Newspapers* [1952], 1935
The Sphere, 'The Romance of the Privy Council', 17 Nov 1937
The Sphere, Nov 1939
The Sphere, 'Castaway on His Own Ship & A Tudor Love Story', Nov 1939

UNDATED WORKS
The Children's Story and Picture Book (illustrations, cover and endpapers)
Hello! Children, Abbey Story Series (nd.), (cover and illustrations)

Payne's reconstruction of Jacobean lining paper from fragments found in a box dated 1635. The motto 'Ich dien' and initials 'HP' belonged to Henry Frederick, invested as Prince of Wales in 1610. Payne's facsimile was used in the Museum of London's Early Stuart Gallery in 1997.

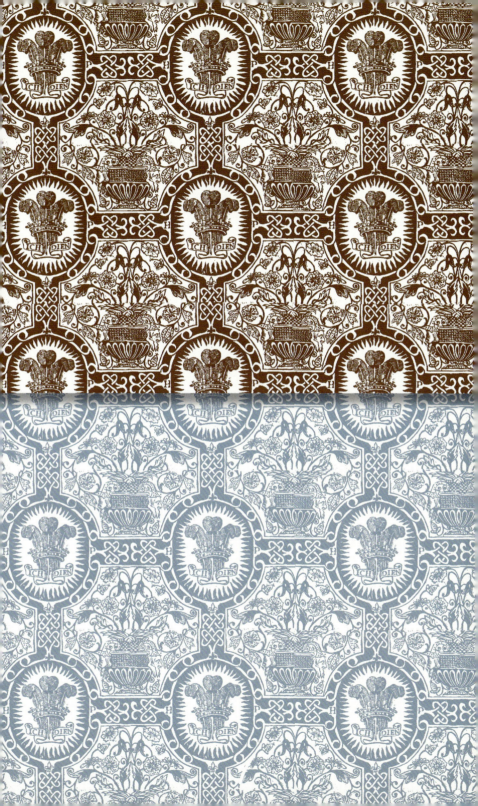